I've always been a looker...

...that's what artists do.

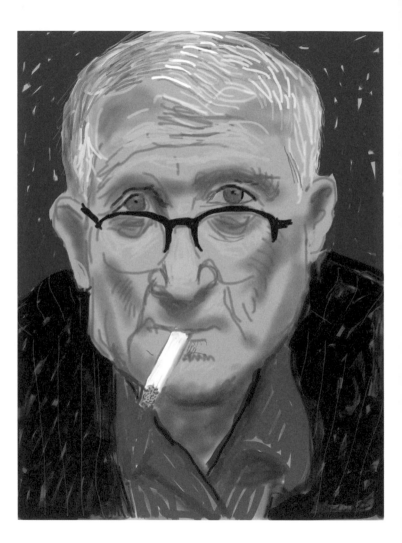

THE WORLD
ACCORDING TO

DAVID
HOCKNEY

Introduction by
Martin Gayford

with 39 illustrations

Cover and front endpaper: *3rd August 2020,* iPad painting (details)

Back endpaper: *Mulholland Drive: The Road to the Studio*, 1980,
acrylic on canvas, 218.4 × 617.2 cm (86 × 243 in.) (detail).
Photo: Richard Schmidt. Los Angeles County Museum of Art (LACMA)

First published in the United Kingdom in 2024 by
Thames & Hudson Ltd, 181A High Holborn, London WC1V 7QX

First published in the United States of America in 2024 by
Thames & Hudson Inc., 500 Fifth Avenue, New York, New York 10110

General Editor: Martin Gayford
Consultant Editor: Andrew Brown
Research by Camilla Rockwood

British Library Cataloguing-in-Publication Data
A catalogue record for this book is available from the British Library

Library of Congress Control Number 2024932557

ISBN 978-0-500-02704-2

Printed in Great Britain by Bell & Bain Ltd, Glasgow

CONTENTS

INTRODUCTION

by Martin Gayford

In a cardboard box in my attic, there is a complete aural record of the very first conversation I ever had with David Hockney. It was the autumn of 1995 and I was interviewing him ahead of an exhibition at the Royal Academy of Arts in London. We had never met before, and he probably had to talk to several other journalists that same morning. And yet, from our first exchange, he was astonishingly eloquent. Epigrams and insights cascaded out of his mouth. One remarkable thought, the first of many preserved on that dusty cassette tape, came about two minutes into our conversation, during a discussion about drawing: 'There's no such thing as an ignorant artist really, if they are an artist they know something.'

There is the authentic voice of David Hockney: pithy, original, and profound. His is a voice so distinctive that it rings off the printed page. When you read his quips and observations, including

those collected in the following pages, you can almost hear him speaking. Just as he has an absolutely characteristic line – no one else draws quite like Hockney – he also has a completely idiosyncratic mind. No one else thinks quite like Hockney either. What's more, few have his level of intellectual and artistic self-confidence.

A bit further into my transcription of the recording, a characteristic phrase appears: 'As usual people have got it wrong!' Hockney was describing his indignant reaction to being invited to take part in a debate on the question 'Is Painting out of the Picture?' He wrote back to the organizers saying that he had heard a lot about painting dying. But in fact it was quite the opposite. 'It's actually photography that's changing, and it's painting and drawing that are altering it, because the computer is being used to change photographs.' He's still making that point today almost thirty years later.

Hockney's friend Henry Geldzahler used to claim that another of his favourite phrases was 'I know I'm Right.' (The painter, amused by this observation, had some T-shirts printed with the slogan, 'I know I'm Right! D. Hockney') But, it seems to me, he often is absolutely correct. For example, it is perfectly true that there is no such thing as an ignorant artist – or at least not one

who is any good. To be a good artist requires a sense of the world: how it is, how it works. This understanding may be intuitive and uninformed by academic learning, but it has to be there. Hockney certainly has this. But he has much more too. There may be no such thing as an ignorant artist, but there certainly are inarticulate ones – and others whose ideas are too complex or coded to be easily comprehensible. But, obviously, none of those descriptions applies to Hockney. He belongs to a select group of visual artists that also includes Vincent van Gogh, John Constable, and Andy Warhol. All of these, like Hockney, had a sense of language as acute as their eye for line and colour.

Although he is the author of several books, Hockney takes the view that he is a painter not a writer. However that may be, he plainly is a brilliant talker. While relaxing outside the studio, he is an indefatigable reader of fiction, non-fiction, poetry, and prose – all of which may have helped him develop a feeling for words that is both personal and precise.

Nor are good artists necessarily wise. Indeed, the lives of the painters and sculptors suggest the contrary. But Hockney seems to have had an inbuilt sense not only of how to follow his own path as a maker of pictures, but also how to live his life.

Of course, he would immediately point out that we are all different inside, and what suits him might not everyone else – or indeed anyone apart from him. How many of us would enjoy spending hours watching raindrops fall on a puddle? Or become so immersed in drawing a blossoming fruit tree that we lose all sense of passing time? Nonetheless, Hockney's observations on human existence are as acute as his thoughts on drawing or photography.

He has a naturally philosophical turn of mind as well as a wonderfully down-to-earth turn of phrase. When he remarks that one might as well try to reach the outer reaches of the universe on a bus as in a spaceship, he is not only correct in astrophysical terms, the way he says it is also utterly memorable. Hockney is the absolute opposite of ignorant. He is an erudite person, a highbrow and a polymath. But when he speaks, just as when he draws, paints, or makes a picture in some other way, he communicates with such clarity and charm that you forget all that. And, as you will discover as you read on, he is virtually incapable of saying a boring thing.

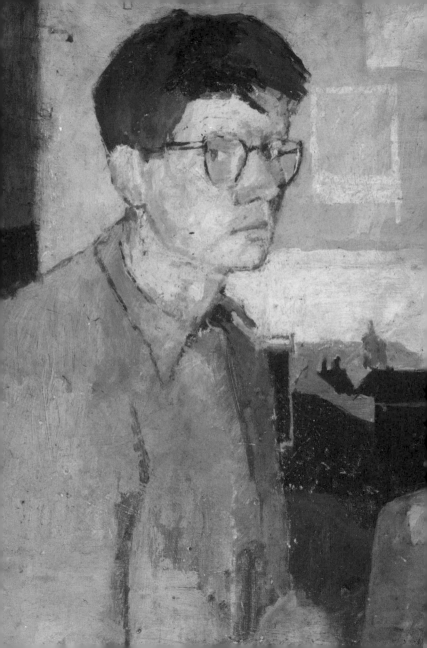

HOCKNEY ON HOCKNEY

...*THEN*

What do you depict? That was one of the big questions when I was young.

I was born just before the Second World War
and you didn't travel much in those days.
We didn't even know people who had been to
London – it was a long, long way away.

*

As a child, I used to cycle to York Minster and
climb to the top of the tower. It seemed old.
But when you're sitting in the temple at Luxor,
600 years seems practically modern.

*

In Bradford, the light was grey, mostly. I'd noticed
the shadows in movies and I knew Hollywood
was a place with sun, so I wanted to go there.
Like Van Gogh going to Arles.

*

I used to paint just around where I lived.
Eventually, I got a pram and put the paints in
it, and I'd wheel it out and it was a lot easier.

*

La Bohème was the first opera that I saw, in
Bradford about 1949. I didn't know anything
about the music then, but I liked it.

Bradford was
a dark city, with
black buildings
from the coal.
I left it in 1959
and never really
went back.

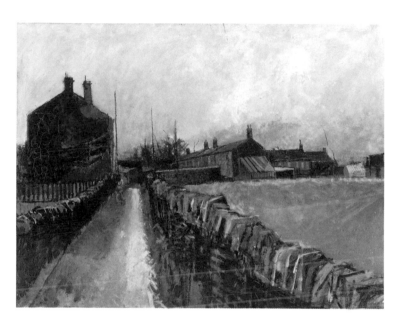

Tunwell Lane, 1957, oil on canvas, 73.7 × 91.4 cm (29 × 36 in.)

I was eighteen when I first came to London.
The first thing I did was to run out of King's Cross
Station just to see all the red buses – anything –
because it didn't look like Bradford.

*

I went to lots of small museums in London
because I thought I had to catch up. Every little
one in London I have been in.

*

It's difficult to say why I decided I wanted to be
an artist. Obviously, I had some facility, more
than other people, but sometimes facility comes
because one is more interested in looking at things,
examining them, and making a representation of
them, more interested in the visual world, than
other people are.

*

At the Royal College of Art, people used to mock me:
'Trouble at t'mill, Mr Ormondroyd', stuff like that.
I didn't take any notice, but sometimes I'd look at
their drawings and think: 'If I drew like that, I'd keep
my mouth shut.'

When I went to art school, a neighbour said, 'Some of the people in the art school just don't work at all. Lazy buggers.' And I said, 'Oh, I am going to work, don't worry.' And I did.

The one good thing about swinging London
was that there was a lot of energy released from
working-class kids.

*

I remember, when I was a student, finding a copy of
Tolstoy's *What is Art?*, and in my naivety I expected
that on page twelve he would say what it was. Now
I realize the question cannot be fully answered.

*

I found that anything could become a subject of
a painting – anything was material you could use.
That in itself made me feel free.

*

In my studio at the Royal College, I had a teapot
and a cup, and I bought a bottle of milk and packets
of tea – it was always Typhoo tea, my mother's
favourite. The tea packets piled up with the cans
and tubes of paint and they were lying around all
the time.... This is as close to pop art as I ever came.

*

On the chest of drawers at the end of my bed,
because that's the first thing I saw when I woke
up, I painted 'Get up and work immediately'.

In about 1963, I realized that I could live from selling the work I made. And I thought to myself, well then, you're rich!

*

In the 1960s people firmly believed abstraction was the way painting had to go. There was no other way out. Even I felt that, and I still felt it when I began to reject it.

*

I can remember a precise moment when I realized that the shape of the picture gave it a great deal more power.

*

What I heard about Diaghilev was, he was homosexual and absolutely accepted it, and I thought, that's what I will do, just accept it.

*

These [early] pictures were partly propaganda of something I felt hadn't been propagandized, especially among students, as a subject: *homosexuality*. I felt it should be done. Nobody else would use it, but because it was a part of me it was a subject that I could treat humorously.

I knew when I was very young that gay people hid things and I didn't want to do that. I thought: 'Well, I'm just going to be an artist, I have to be honest.'

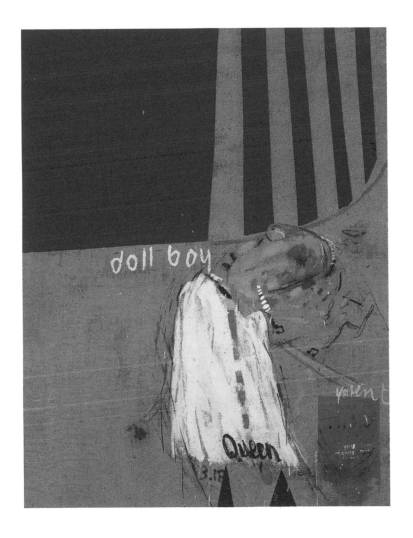

Doll Boy, 1960–1, oil on canvas, 121.9 × 99 cm (48 × 39 in.)

[New York] was very stimulating, the gay bars – there weren't many in those days; it was a marvellously lively society. I did quite a lot of drawings then.

*

Boring old England. You can't do this, you can't do that. That's why I went to California all those years ago.

*

California in my mind was a sunny land of movie studios and beautiful semi-naked people.

*

Within a week of arriving in LA, not knowing a soul, I'd passed the driving test, bought a car, got a studio, started painting. And I thought, it's just how I imagined it would be.

*

California has a very clear light. You can see a hundred miles sometimes. It's very, very clear and that's what I loved about it.

*

California was always good for me.

California was
the place I always
used to run to.

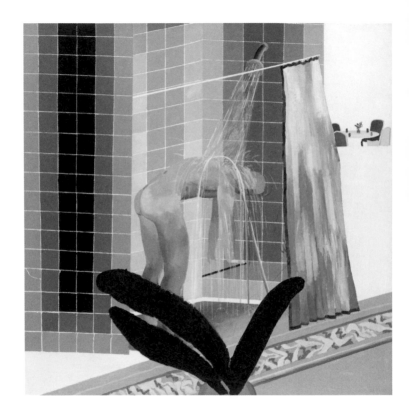

Man in Shower in Beverly Hills, 1964, acrylic on canvas,
166.4 × 166.4 cm (65½ × 65½ in.)

For an artist,
the interest in
showers is obvious:
the whole body is
always in view
and in movement,
usually gracefully,
as the bather
is caressing his
whole body.

The idea of painting moving water in a very
slow and careful manner was appealing to me.

*

In the summer of 1975 I went for a month to
The Pines, on Fire Island, which was a kind of
mad, gay resort. I had a lovely month.

*

Egypt is one of the most thrilling countries I've ever
been to.... In Luxor, where there are lovely sunsets,
I'd sometimes sit and watch the river.... I always find
this stimulating to my imagination. I drew all the
time I was there.

*

Sitting on the banks of the Nile, alone, I was thinking
that perhaps we live in a very arrogant age. You
start thinking of things like this in Egypt because
of the very long historical periods involved.

*

I noticed in China that as time went on my drawings
got more and more Chinese: I started using brushes
and flicking ink.

Whenever
I left England,
colours got
stronger in
the pictures.

California always affected me with colour. Because of the light you see more colour ... there is more colour in life here.

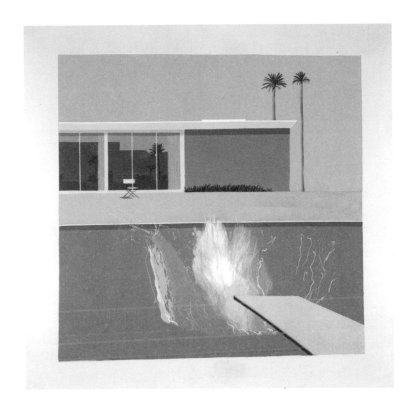

A Bigger Splash, 1967, acrylic on canvas, 243.8 × 243.8 cm (96 × 96 in.)

Work in the theatre is ephemeral. I do models,
but the models are nothing, the sets are nothing,
without the music.

*

All the work I have done in the theatre has been
useful to me and I have never regretted any of
the time spent on it.

*

Theatrical design is about creating different
kinds of perspective, but the perspectives can't be
quite real, because they have to create an illusion.
That's why I liked designing operas.

*

I'd just got a little house in Malibu and I was
driving around to explore, playing Wagner
a bit loud. Then I suddenly thought, 'My God!
The music matches these mountains.'

*

I painted the terrace of my house blue in 1982.
The painters thought I was mad. But when they
finished, they saw how good it was.

The only reason
you do an opera
is because of the
music; if that is
no good, it doesn't
matter what the
story is.

I thought I was a hedonist, but when I look back, I was always working. I work every day. I never give parties.

I know a lot of people who simply live for sex.
They want somebody new all the time, which means
it's a full-time job; you can't do any other work.

*

A person came to see me in Paris from *The Advocate*,
a gay newspaper. And I had to say, 'The trouble is,
it doesn't dominate my life, sex, at all.'

*

When people go on as though sex was a pioneering
thing, I say, Well, it's really very far from that.

*

Aids changed New York. The first person to die
of Aids that I knew was in 1983, and then for ten
years it was lots of people. If all those people were
still here, I think it would be a different place.

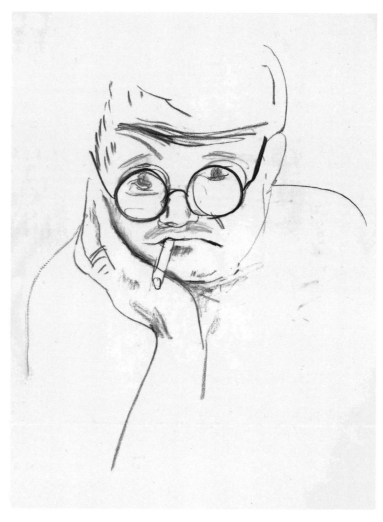

Self Portrait with Cigarette, 1983, charcoal on paper,
76.2 × 57.2 cm (30 × 22½ in.)

Every few years,
I do a series of
self-portraits....
There was a rash
of them in 1983,
when I suddenly
became more
aware of aging.

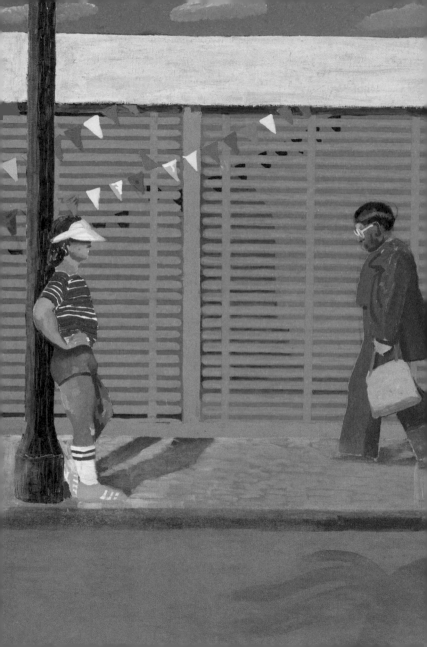

HOCKNEY
ON LIFE

Life is exciting, interesting, thrilling.

I'm not greedy for money – I'm greedy for
an exciting life. On the other hand, I can find
excitement in raindrops falling on a puddle.

*

There are times in your life when you travel, or
are in one particular place, and you can remember
almost everything about a day.

*

We see with memory. There's no objective vision
ever – ever.

*

I was driving someone up here and I asked them
what colour was the road. Ten minutes later, I asked
the same question, and he saw it was different.
He said, 'I'd never thought what colour the road was.'
Frankly, unless you're asked, it's just road colour.

*

You have to live in the here and now. It's the now
that's eternal.

*

I know why they go on smoking in Greece: they
know that time is elastic and there is only now.

The world is very, very beautiful if you look at it, but most people don't look very much, with an intensity, do they?

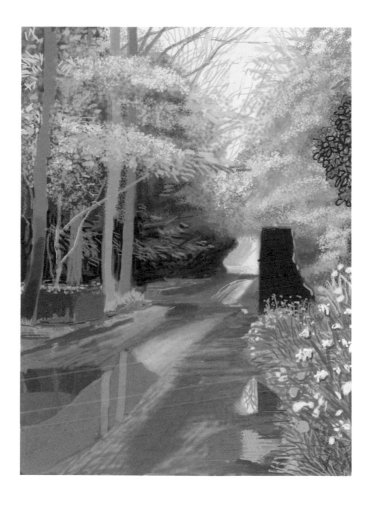

The Arrival of Spring in Woldgate, East Yorkshire in 2011 (twenty eleven),
11 May, iPad drawing

Pompeii was the Beverly Hills of its time; there
were brothels and masses of pictures everywhere.

*

That's what we should do every now and again,
be excessive.

*

Most people who go out to lunch have nothing
to do in the afternoon.

*

The nice thing about America is that the bars
are open very late.

*

You can smoke, drink, do all kinds of things, but you
need a sense of purpose: you need a big job to do.

*

They may be different, but we all get one lifetime.
Look at Balzac: dead at fifty-five, but he produced
a hundred years of writing and did it perfectly.

*

From everything I read about Ravel, I would have
loved the man.

Artists, even when they're dead, are alive in their work.

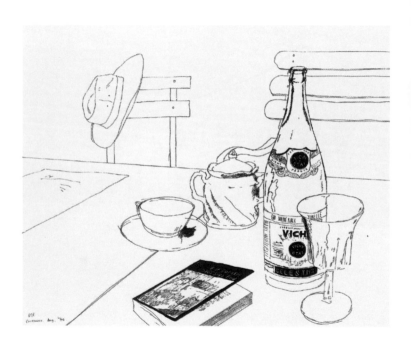

Vichy Water and 'Howard's End', Carennac, 1970,
ink on paper, 35.6 × 43.2 cm (14 × 17 in.)

It's good to rest
and read.

The eye is
always moving;
if it isn't moving
you are dead.

We live in an age when vast numbers of images
are made that do not claim to be art. They claim
something much more dubious ... to be reality.

*

You're never going to get to the edge of the universe
in a spaceship. You might as well try going on a bus.
You can only go there in your head.

*

Most objects in the universe don't have any colour;
but the Earth has wonderfully varied colour, which
I think makes us special: blue, pink, and green.

*

We do not look at the world from a distance; we are
in it. I like the thought that I'm in the world. I don't
want just to look through keyholes.

*

I like looking at the world. The world is exciting,
even if a lot of pictures are not.

*

Visual education is treated as if it's unimportant,
but the things we see around us affect us all our lives.

The world is beautiful and if we don't think it is,
we are doomed as a species.

*

We might save ourselves from destruction by
admitting what is close, what is intimate, which is
what is real, by perceiving the world with greater
intimacy, which, in turn, leads to kindness.

*

A lot of people think they know what the world
looks like, they've seen it on television.

*

When you look out at the world, there is a lot there.
We edit it.

*

When you look casually at the graffiti on a wall, you
don't see all the smaller messages; you see the large
ones first and only if you lean over and look more
closely do you get the smaller, more neurotic ones.

*

Each individual person feels or knows that he
or she has a unique sort of experience.

We can't all be seeing the same thing; we are
all seeing something a bit different.

*

If a friend tells me to see something, I don't care
what the review says, I believe my friends more.

*

People need something to enjoy, something pretty
and full of coloured lights.

*

My dogs never look at the TV. However, in Malibu
they sit and peer out at the sea's edge. Fire and
water are neverending shapes, constantly changing,
and the dogs are as interested in that as we are.

*

You can't measure pleasure, can you?

*

Laughter is the only time that our fight-or-flight
response is turned off. It's good for you.

*

I have a good laugh every day. You've got to.
That's what keeps you going.

Artists don't care about class. But I think it does affect English art. I'm sure it's the class system that drives a lot of people abroad.

*

If you're an artist, the one thing you can do when you get money is use it to do what you want to do in art.

*

The vanity of artists is that they want their work to be seen. More than anything else, that's what you want.

*

You wouldn't be an artist unless you wanted to share an experience, a thought. I am constantly preoccupied with how to remove distance so that we can all begin to sense we are the same, we are one.

*

If you can love fully, in the full sense of the word, you have less fear.

*

You can't force relationships; they just happen.

The space
between where
you end and
I begin is the
most interesting
space of all.

Love is the only
serious subject.

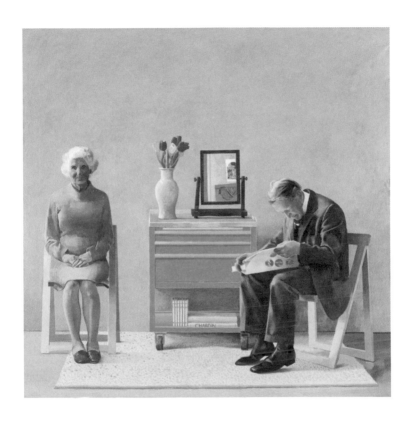

My Parents, 1977, oil on canvas, 182.9 × 182.9 cm (72 × 72 in.)

If I described my own, as it were, suffering, it would be loneliness. But I stop myself because there's always somebody else worse off and I can manage.

*

I think longevity is a by-product of a harmonious life. If you live to be older, you find your own rhythm.

*

If everything's directed at maximizing the number of years you live, you're denying life itself.

*

Some leaves fall off the tree faster than others.... Like people. Some die earlier, some die later.

*

I've had quite a lot of friends die who were much, much younger. An old person dying seems perfectly natural, whereas somebody aged thirty-two is not.

*

We were recently in San Francisco. It's a very boring city now. Where are the Harvey Milks?

*

If the young can't move in, cities die.

The past is edited so it always looks clearer to us.
Today always looks a bit of a jumble.

*

It is always difficult to see the present.

*

Today, everybody's in gym clothes. Fashion's
gone very dull, I think.

*

I have never been to a gym in my life.

*

New ideas often seem to go against common sense.

*

People say Americans worship success while in
England they hate it. I think this means they are
both taking it too seriously.

*

I used to feel I should shout and stand up for things,
and I did an awful lot, but I got fed up sometimes.
People thought, 'Oh, it's just David going on,
moaning away again in that Bradford accent.'

It used to be you
couldn't be gay.
Now you can
be gay but you
can't smoke.
There's always
something.

Restaurants and pubs have got rid of smokers – but I think they have cleared out the wrong pollutants. The real one for me is noise.

*

There are aspects of English life that have always irritated me greatly. People never seem to get anything done.

*

It is the same little people, small, unimaginative minds, frightened to death of things. I don't mind them, but they shouldn't be running the country.

*

I've always thought it was a mad world and I've said so, but I think it's going a bit madder now.

*

It seems to me that, however rotten you might think the world is, it is always possible that there is something quite good about it.

*

If you see the world as beautiful, thrilling, and mysterious, as I think I do, then you feel quite alive.

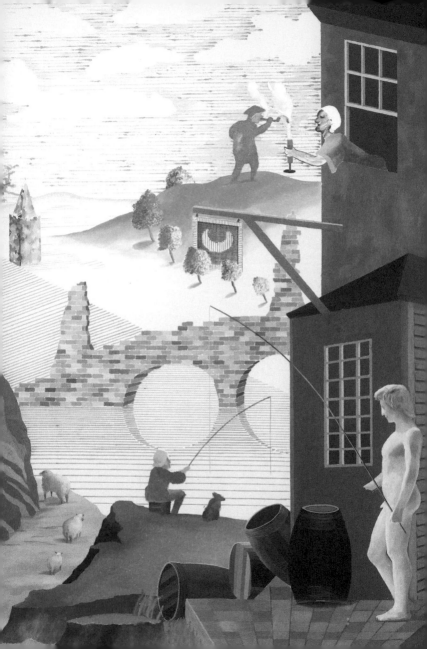

HOCKNEY
ON ART

Pictures make
us see the world.
Without them,
I'm not sure
what anybody
would see.

I had an argument once with a writer who told
me art is not for everyone. I found this shocking.
I do not think we can live without art of some form.

*

Art doesn't progress. Some of the best pictures
were the first ones.

*

Pictures have been helping us see for at least
thirty thousand years.

*

The first person to draw an animal was watched by
someone else, and when that other person saw that
creature again, he'd have seen it a bit more clearly.

*

Pictures are texts – and they'll tell you a lot.

*

The art of the past is living; the art of the past
that has died is not around.

*

The ancient world was all coloured, so were
the Middle Ages. The paint has come off now.

If you look at
Egyptian pictures,
the Pharaoh is three
times bigger than
anyone else. He
was bigger – in the
minds of Egyptians.
Their pictures are
truthful, but not
geometrically.

A Grand Procession of Dignitaries in the Semi-Egyptian Style, 1961,
oil on canvas, 213.4 × 365.8 cm (84 × 144 in.)

From the Renaissance, artists were very keen
to place themselves above the level of trade, so they
played down the element of craft. I believe they used
cameras, but were a bit ashamed of them.

*

We've been led to believe that before photography,
cameras were always big bulky things like early
television sets. Actually, all you need to make an
optical projection is a piece of glass.

*

If you are involved with making depictions, you
are bound to be alert to how many ways there are
of portraying the world. I think Caravaggio, for
example, made his pictures by a form of drawing
with a camera. He was projecting first this figure
then that figure – or part of a figure, an arm or
a face – onto his canvas. His paintings are a kind
of collage of different projections.

*

Some historians seem to imagine that Van Eyck's
studio would have been like Cézanne's: the artist's
lonely vigil. It wouldn't have been like that at all.
It would have been more like MGM: costumes,
wigs, armour, chandeliers, models.

It is a kind of joke, but I mean it when I say
Caravaggio invented Hollywood lighting.
He worked out how to light things dramatically.

*

Rembrandt put more in the face than anyone
before or since, because he saw more. That was
the eye – and the heart.

*

Anyone who's ever drawn sees how wonderful
Rembrandt's drawings are; the economy of means
takes your breath away. You can *see* the speed.

*

There's a drawing by Rembrandt, I think it's
the greatest drawing ever done. It's in the British
Museum and it's of a family teaching a child to walk.

*

When Hokusai was drawing his bridges, there's no
shadows under those bridges.... Most people don't
even notice. They just see it as a beautiful picture.

*

In the past, if art did not work for most people,
the artists were not considered to be much good.

A curator said to me that he *hated* Renoir. I was shocked by that. I said, 'What word would you use to describe your feelings for *Hitler* then?' Poor old Renoir. He hadn't done anything terrible: he'd painted some pictures that pleased a lot of people.

<div align="center">*</div>

Van Gogh was one of the great, great draughtsmen. I love the little sketches in his letters. These days he'd be sending them on his iPhone.

<div align="center">*</div>

Any art or artist that speaks to you is contemporary. Van Gogh, to me, is a contemporary artist.

<div align="center">*</div>

That Matisse show was unbelievable. It was pure joy.... And joy is a great thing to give to people.

<div align="center">*</div>

Art should be about joy.

<div align="center">*</div>

The pleasure principle in art can't be denied; but that doesn't mean all art is easy and joyful. One can get a deep pleasure from a picture of the Crucifixion.

Art should be a deep pleasure. There is a contradiction in an art of total despair, because at least you are trying to communicate, and that takes away a little of the despair. Art has this contradiction built into it.

*

You can't have art without play. Even a scientist has a sense of play. And that allows for surprises, the unexpected.

*

Someone once said to me while we were talking about Cubism, Isn't Cubism about the inner eye? I said, But that's all we have, that's all there is.

*

Painters must, to a certain extent, analyse their work afterwards. I'm sure the Cubists didn't plan it, they didn't sit down and say, 'Well, perspective has to be broken, that's what the problem is.' It's a groping, they're groping slowly and in different ways.

*

The idea of a permanent avant-garde going on and on and on is absurd.

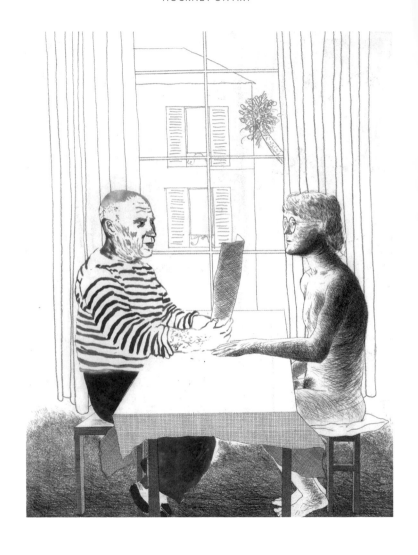

Artist and Model, 1973–4, etching, 75.6 × 58.4 cm (29¾ × 23 in.)

I am very conscious
of all that has
happened in art
during the last
seventy-five years.
I don't ignore it;
I feel I've tried to
assimilate it into
my kind of art.

Duchamp played very interesting, enjoyable games, but a school of Duchamp is a bit unDuchampian, isn't it? He would laugh at it.

*

I always agreed with Bacon about abstraction, I used to think 'How do you push this?' It can't go anywhere. Even Pollock's painting is a dead end.

*

Abstraction at first looked as though it was going to lead to everything, but it doesn't, does it?

*

Landscape and portraiture are the subjects modernists said you couldn't do any more. But you can, everything is open now. Landscape and portraiture remain infinite.

*

When Adolf Loos said ornament is crime, he made criminals of honest craftsmen.

*

If you set up a rule about anything, another artist will come along and break it.

There is no such thing as a perfect copy,
because each copy is an interpretation.

*

A two-dimensional surface can easily be copied on
two dimensions. It's three dimensions that are hard
to get on two; you have to stylize it, interpret it.

*

Two dimensions is only an idea, it doesn't exist in
reality; even a piece of paper is three-dimensional.

*

A silhouette is very distinctive. We can recognize
people from one, even from a long way away.

*

Often stepping back you see more, don't you?

*

Images have power, they are used to control.

*

The way the world is depicted has a deep effect
on us.... Art still has an immense influence on
the way we perceive the world.

A still picture can have movement in it because the eye moves.

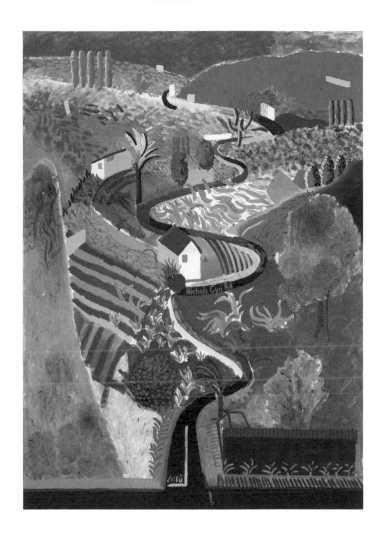

Nichols Canyon, 1980, acrylic on canvas, 213.4 × 152.4 cm (84 × 60 in.)

I was living up in the hills and painting in my studio down the hills, so I was travelling back and forth every day, often two, three, four times a day. I actually *felt* those wiggly lines.

*

It's the fact that it takes us time to see it that makes the space.

*

You bring your time to a painting; a film imposes its time on you.

*

We remember still pictures better. They go into the head much more deeply. It's difficult to recall a movie sequence.

*

Most images are just forgettable.

*

We are forced to make depictions. We have made them for ten thousand years now, and we are certainly not going to stop. There's a deep, deep desire within us that makes us want to do it.

We obviously want to see pictures, don't we? We are geared to seeing images. If we put down four marks, everybody knows it could be a face.

*

Even if one isn't going to be an artist ... art training sharpens the visual sense, and if people's visual sense is sharp, you get beautiful things around you.

*

There are more people than one thinks who are interested in pictures.

*

Very few people know what the truly significant art of today is. You'd have to be incredibly perceptive to do so. I wouldn't make a judgment on that. The history books keep being changed.

*

Art history, like all history, is going to be rewritten.

*

Artists tend to see art in more open ways than historians; they are less interested in where or when it was made.

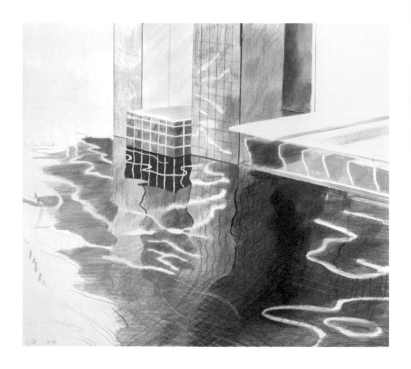

Study of Water, Phoenix, Arizona, 1976, coloured pencil on paper,
45.7 × 49.8 cm (18 × 19⅝ in.)

In the end,
it's pictures
that make us
see things.

Believe what
an artist does,
rather than
what he says
about his work.

Art comes in all kinds of forms. We need all kinds of artists.

*

I like variety in pictures.

*

I like clarity, but I also like ambiguity. You can have both in the same painting, and I think you should.

*

The main reason why pictures, and other things, survive is because someone loves them.

*

That's why auction prices are so high, because in the end – after you've got a roof, food and warmth – all you can buy is beauty.

*

Drawing and painting will carry on, like singing and dancing, because people need them.

*

Art is not going to die. Even painting isn't going to die.

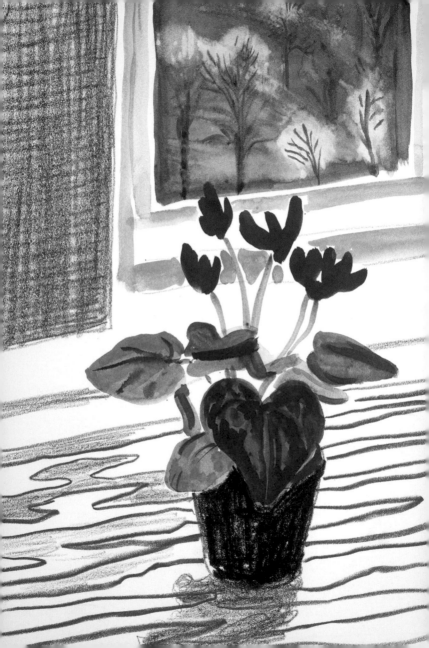

HOCKNEY
ON
INSPIRATION

If you are deeply fascinated by what the world really looks like, you are forced to be interested in any way of making a picture.

*

You should paint what you love! I'm painting what I love; I've always done it.

*

A very beautiful boy danced the cha-cha especially for me at one of those college dances. It had such an impact on me, I thought, maybe here's another thing I can make a picture of.

*

I paint what I like, when I like, and where I like, with occasional nostalgic journeys ... I am sure my inspirations are classic, even epic themes. Landscapes of foreign lands, beautiful people, love propaganda, and major incidents (of my own life). These seem to me to be reasonably traditional.

*

I've always assumed that one of my relatives must have been a cave artist who liked making marks on the wall.

Every time I go out, I see something to draw.
I just look somewhere and I start.

*

I've always had intense pleasure from looking.
In a car, I always want to sit in the front because
it is such a pleasure.

*

If you'd locked van Gogh in the dullest motel
room in America for a week, with some paints
and canvases, he'd come out with astonishing
paintings and drawings of a rundown bathroom
or a frayed carton.

*

The swimming pool paintings I did were about
transparency: how would you paint water?

*

The swimming pool, unlike the pond, reflects light.

*

Water in swimming pools changes its look more
than in any other form – its dancing rhythms reflect
not only the sky but the depth of the water as well.

Every artist I know sticks reproductions of paintings, printed images, on his or her wall – posters, postcards, anything.

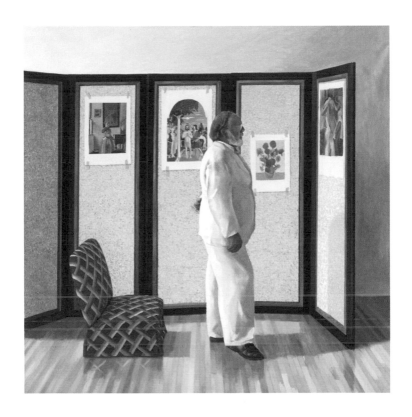

Looking at Pictures on a Screen, 1977, oil on canvas, 188 × 188 cm (74 × 74 in.)

I've had a permanent affair with the art of
the past and it goes hot and cold.

*

Everybody's looking at the same picture, but
they don't necessarily see the same things.

*

We are all seeing something different. Images on
a printed page evoke different memories.

*

Cézanne's innovation was recognizing that
viewpoints are in flux, that we see things from
multiple, sometimes contradictory, positions.

*

Cézanne, painting with two eyes, was seeing
things from two slightly different points of view.
That's why his curves are a bit odd.

*

The Chinese say you need three things for paintings:
the hand, the eye and the heart. Two won't do.

It's not possible to separate what you're looking
at from yourself; it's connected with you when
you're looking at it.

*

The more I look and think about it, the more
I see. Simple little things are unbelievably rich.
A lot of people have forgotten that. But you
can remind them.

*

I walked every morning through Holland Park.
I noticed the spring and I thought: 'Oh, it's very
exciting, this. Very exciting.'

*

I look out at the sky every morning, because each
day it will be different.

*

We saw an extraordinary landscape from the plane
and we were thrilled.... Landscape is a spatial thrill.

*

If there's dirt on the glass, you can look at that
for a while, and then if you look through the glass
you don't see the dirt.

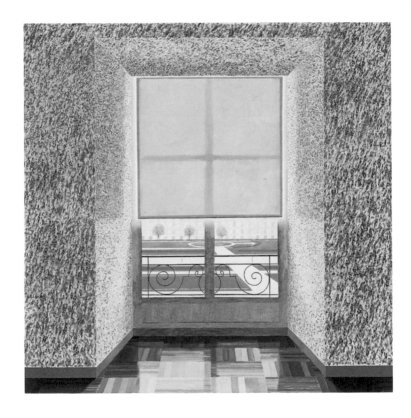

Contre-jour in the French Style – Against the Day dans Le Style Français, 1974, oil on canvas, 182.9 × 182.9 cm (72 × 72 in.)

I saw this window with the blind pulled down and the formal garden beyond. I thought, oh, it's marvellous, marvellous! This is a picture in itself.

Each time I do a still life, I get very excited and realize that there are a thousand things here I can see! Which of them shall I choose?

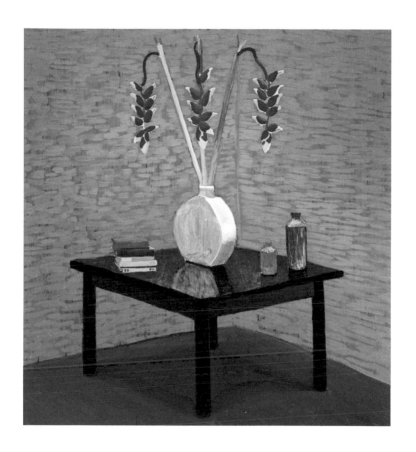

Halaconia in Green Vase, 1996, oil on canvas, 182.9 × 182.9 cm (72 × 72 in.)

Faces are the most interesting things we see;
other people fascinate me, and the most interesting
aspect of other people – the point where we go
inside them – is the face. It tells all.

*

We are always fascinated by visual magic.

*

I've often thought about the way I see.
For years, I've thought my eyes are funny
or something. I kept thinking how much can
you really see and what is it you really take
in as your eye moves about focusing.

*

I often have these strange ideas in the morning,
the moment before I am fully awake. I assume
this happens because the mind is free. When we
are awake, too much gets in the way.

I have this urge, this compulsion, to share my enjoyment, which is what artists do usually. Most artists have that urge.

HOCKNEY
ON
MAKING ART

I have to paint. I've always wanted to paint pictures,
from when I was tiny. That's my job, and I've gone
on doing it for over sixty years.

*

I draw all the time. Wasn't it Degas who said,
'I'm just a man who likes to draw'? That's me!

*

I'm doing a lot of drawings of the dawn and vases
of flowers in bed, because I've got this lovely window,
and the flowers are there and the light's changing.

*

Children usually want to draw something that's
in front of them: 'I'll make you a picture of the
house.' That suggests a deep, deep desire to depict.

*

Most people can draw a tree because we don't care
that much if a branch is a bit wrong. But if an arm
is a bit wrong, everybody notices.

*

Teaching someone to draw is teaching them to look.

I think you can train visual memory a bit if you are painting. You decide: I shall go and look at this aspect this morning.

Drawing makes you see things clearer and clearer, and clearer still.

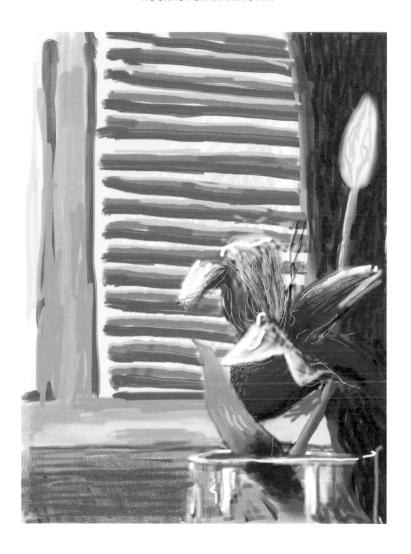

No. 182, 15th June 2010, iPad drawing

As I got deafer, I could see space more clearly.

*

When you are working outside, you realize that
it's changing all the time – *all* the time. Then you
see how quickly the clouds move. That's why
Cézanne preferred overcast days.

*

All the skies I've drawn have been from nature.
You can't invent a sky ... if you do, it's obvious.

*

With the bright sun, you get the deepest shadows.

*

You get shadows when you light objects. But if you're
lighting flat surfaces, you've got to paint the shadows.

*

You can ignore shadows when you are drawing,
as the ancient Greeks did.

*

There's a point where you've got to interpret
the world, not make a replica of it.

The moment you cheat for the sake of beauty,
you know you're an artist.

*

What did Picasso say? 'If you haven't got any
red, use blue.' Make blue look like red.

*

Michelangelo, Picasso – they worked all the
time. You never hear about artists staying in bed,
because they don't.

*

If any artist tells you he's not having fun in
the studio, there is something wrong with him.

*

In Santa Monica, in a *tiny* little room, I painted
Beverly Hills Housewife which is twelve feet long.
The truth is that you don't need great big studios.

*

My joke used to be, when people said I was untidy,
'Well, I have a higher sense of order.'

*

Looking is a positive act. You have to do it deliberately.

Once my hand
has drawn
something my
eye has observed,
I know it by heart,
and I can draw
it again without
a model.

The eye is part of the mind.

*

Everybody likes watching people draw.

*

The moment you put down two or three marks
on a piece of paper, you get relationships. They'll
start to look like something.

*

Most people don't look at a face too long; they tend
to look away. But you do if you are painting a portrait.

*

The most interesting thing we look at is another
human being, so that is the hardest thing to draw.

*

I paint what I see. If there's a little tummy you
get it in the picture.

*

I can't just paint the figure theoretically. If it is
not there, you deal with the fact that it's not there,
you deal with the absence.

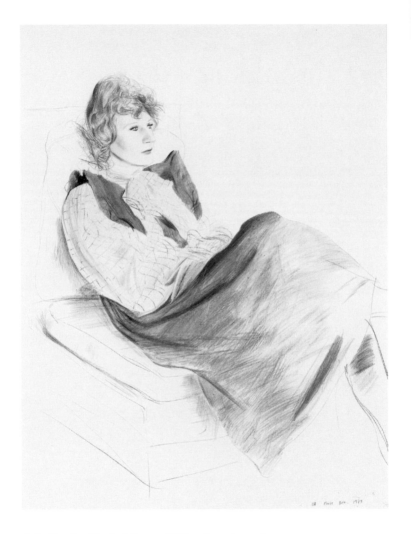

Celia Wearing Checked Sleeves, 1973, coloured pencil on paper,
64.8 × 49.5 cm (25½ × 19½ in.)

I'll make some
drawings of my friends;
I'll make them slowly,
accurately, have them
sit down and pose
for hours, and so on.
I tend to do that at
times when I feel a
little lost.

Everybody chooses their shoes. But it's unusual for portraits to have shoes in them.

*

Your face belongs to other people. That's one reason why I am still doing portraits with no signs of boredom.

*

A portrait should be done quickly.

*

I like painting the people that I know again and again. It takes a long time to get to know how somebody looks and maybe you never really can.

*

I'm still not sure what people look like.

*

I never talk when I'm drawing a person.

*

When I'm painting, I'm in silence.

The mood you're in always comes out in your work. My awareness of my loss of hearing coincided with my irritation at spatial flatness.

*

There are many ways of translating three dimensions into marks on a flat surface.

*

Medieval artists often used isometric perspective, as did Chinese, Japanese, Persian, and Indian ones. The idea that those artists didn't get perspective *right* is ridiculous. There is no such thing as 'right' perspective.

*

In isometric perspective the lines don't meet at a vanishing point; everything remains parallel. You could say it is more real, closer to how we actually see. We have two eyes, constantly moving.

*

Perspective is really about us, not the object depicted.

In real life when you are looking at six people,
there are a thousand perspectives.

*

If you're told to do a drawing using ten lines
or a hundred, you've got to be a lot more inventive
with ten.

*

Limitations in art have never been a hindrance.
I think they are a stimulant.

*

I get into traps; any artist will get into traps.
You just begin to feel it. Sometimes it's easier
than at others to get out of them.

*

I'm always having doubts; they're always there
and I assume they always will be.

*

Most artists, good artists, trust their intuition.
I trust mine. Sometimes it leads you to make
mistakes, but that hardly matters.

When you make a move in painting it's not as
though you wake up one morning and decide to
make the move. It's very gradual, and often you
don't even know you're making the move till
you can look back.

*

When you stop doing something, it doesn't mean
you are rejecting the previous work. It's saying
I have exploited it enough now and I wish to take
a look at another corner.

*

Usually, if a painting goes well from the beginning,
you can keep it going.

*

Sometimes you go off on tangents that turn out
to be cul-de-sacs, so you simply abandon that little
journey, come back to your main road and go on.

*

If you come to a dead end, you simply somersault
back and carry on.

Somebody once commented that my double portraits are like Annunciations; there's always someone who looks permanent and someone who's a kind of visitor.

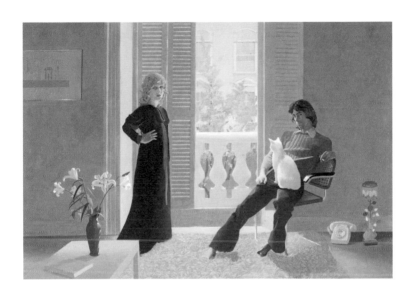

Mr and Mrs Clark and Percy, 1970–1, acrylic on canvas,
213.4 × 304.8 cm (84 × 120 in.)

When you put a word on a painting, it has a similar effect to a figure; it's a little bit of human thing that you immediately read; it's not just paint.

*

All painting, no matter what you're painting, is abstract in that it's got to be organized.

*

The greater the area of a certain colour, the more powerful it is. There's a remark of Cézanne's: two kilos of blue are a lot bluer than one kilo.

*

It is a marvellous thing to put a brush into paint and make marks on anything ... the feel of a thick brush full of paint coating something.

*

That's what I look at first when I see any painting: the paint itself. Then I might see a figure or something else. But first I see the *surface*.

*

If you don't paint with the right stuff, your pictures won't last. That's all there is to it.

Whatever your medium is you have to respond to it.
I have always enjoyed swapping mediums about.

*

I like using different techniques. If you are given
a stubby brush, you draw in a different way.

*

When you are making prints, your mind starts
thinking in layers.

*

With watercolour, you can't cover up the marks.
There's the story of the construction of the picture,
and then the picture might tell another story as well.

*

The moment you make marks, they begin
to play with the surface. The eye might see one
at a different time from another and, therefore,
space is made out of these marks.

*

A drawing or painting may have hours, days,
weeks even years in it.

There is a van Gogh painting of some trees and one time this lady said to me, 'Well, he got the shadows wrong.' She was thinking it was like a photograph, when it's all the same instant of time.

*

I don't mind being alone and working alone on many ideas.

*

Theatre is compromise; collaboration also means compromise; and you *do* compromise and it usually works.

*

I'm not a professional theatre designer. A professional theatre designer takes orders.

*

I work on the assumption that if something I am doing interests me, it might interest someone else; but I can't be bothered too much if it doesn't.

*

If you are learning something from whatever you are doing, you are not going to be put off because somebody says it isn't art.

I'm willing to
collaborate with
people, but I'm
not interested
in illustrating
someone else's
ideas.

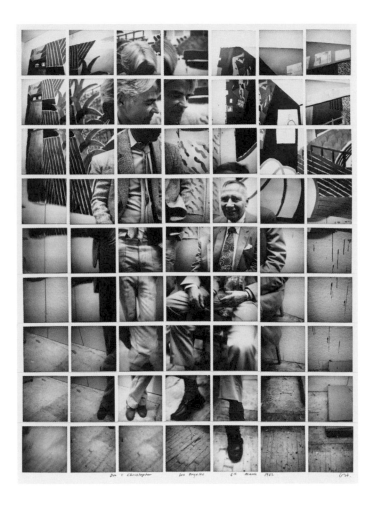

Don and Christopher, Los Angeles, 6th March 1982,
composite Polaroid, 80 × 59.1 cm (31½ × 23¼ in.)

In 1981, I started to play with the Polaroid camera and began making collages. Within a week, I made them quite complex. This intrigued me and I became obsessed with it.

There's a drawing basis to my Polaroid collages.
It lies in the way the edges of each frame relate to
others. It's a matter of making a coherent space.

*

The first time we showed the photo-pieces in
New York, somebody wrote, 'He's done it all wrong.'
I thought, you can't say that, there is no such thing
as being wrong.

*

When my photography was attacked, I just shrugged
my shoulders. I never thought of stopping until
I was ready to stop.

*

If you took notice of critics, you'd be mad.

*

You may not know fully what's going on in a picture.
How would you, in my pictures; how would I know?

*

I keep pictures I have done around the studio;
you want to look at them. And it takes a while
to realize what I really did there, how it works;
then I may use that in something else.

Many painters stay with something they've found. For me, it's important to carry on changing. You've to go *on*.

*

I am an eclectic artist. I feel that there's nothing stopping me now from painting almost anything.

*

I could spend the whole day painting a door just one flat colour.

*

Painting every day wouldn't suit everybody, but it suits me. If you do that, you live in the now.

*

The difficulties of depicting the world in two dimensions are permanent. You never solve them.

*

There is no such thing as failure, you just learn from it and go on.

*

God, if you want to paint, just paint.

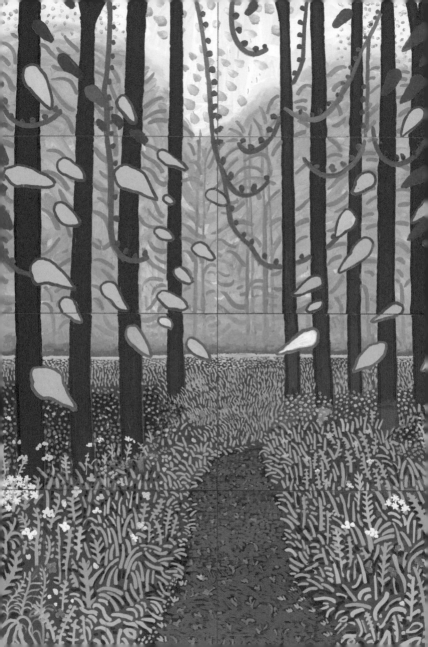

HOCKNEY
ON
NATURE

One of my interests in the Grand Canyon was that when you go to the edge there you just look. There are not many places in nature where you do that; just stand in one place and start looking.

*

LA is a very green city. People think it's all freeways and concrete, but that's not right. Wild animals live around my house near Mulholland Drive.

*

The rain is a good subject for me.

*

Trees are fascinating things. Every one is different, like we are; every leaf is different.

*

Being surrounded by the trees and getting to know them, just by looking at them, you realize why their shape is the way it is, what the reason for it is.

*

Trees don't follow the laws of perspective, or don't seem to, because they are so complicated, with lines going in so many directions.

Trees have a deep appeal, and I think it's partly a
spatial thrill, a kind of thrill I'm very conscious of.

*

Certain hours are best to see the volume in trees.
The sun has to be very, very low to light the trunks.

*

Early morning light is very special; anyone who
is doing a lot of looking will be aware of that.

*

I've always noticed shadows simply because
there weren't many in Bradford.

*

I've really known this [East Yorkshire] countryside
quite intimately since the early fifties, when I came
here to work during breaks from school – helping
with the harvesting of corn. Wheat. Barley. I used
to sack them for transport into Bridlington.

*

When we were first here, the hedgerows seemed
a jumble to me. But then I began to draw them.
I filled the sketchbook in an hour and a half. After
that, I saw it all more clearly.

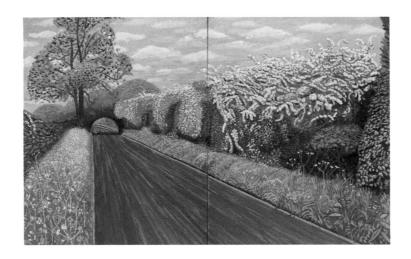

Hawthorn Blossom Near Rudston, 2008, oil on 2 canvases,
overall 152.4 × 243.8 cm (60 × 96 in.)

Blossom doesn't last long. If you are dealing with nature there are deadlines.

When the hawthorn blossom was at its height
in late May and early June, we had two weeks
of unbelievable madness.

*

Spring here [in Yorkshire] takes a good six weeks
of activity. During that period I made forty or
fifty drawings, maybe more. I was out every day,
constantly looking.

*

People just don't notice the spring sometimes.

*

As the spring developed, I realized that I had
to move in closer because it was all about what
was happening on the ground.

*

What's really flat in nature? Nothing.

*

There's a moment when spring is full. We call
it 'nature's erection'. Every single plant, bud
and flower seems to be standing up straight.

We did a lot of filming on a misty morning. The mist makes you see more: a marvellous range of greens, more detail in the cow parsley.

*

Only after seeing the winter do you comprehend the richness of summer.

*

I had to watch the pond for about ten minutes, out there in the rain, then I came in and drew it.

*

It wasn't the pool itself that interested me; it was the water and the transparency. The dancing lines are on the surface, they're not underneath it. That's what you are looking at in ponds: surface and depths.

*

Everything is in flow. That is one reason why a drawing is so interesting, as opposed to a photograph. I like that remark of Cézanne's: 'You have got to keep painting because it is constantly altering.' Well, it is actually, because we are.

The edge of the
sea is alive, forever
moving. Living
there, its rhythms
affect you. [In Malibu]
I sat and painted
in a little room with
my back to the sea.

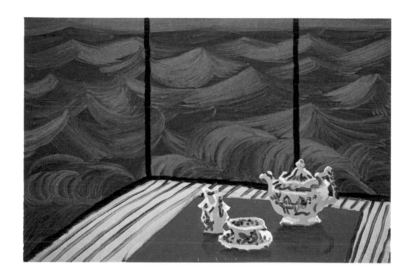

Breakfast at Malibu, Sunday 1989, oil on canvas, 61 × 91.4 cm (24 × 36 in.)

It was a marvellous evening we had, just sitting there. The changing sky was fantastic! Nothing could be a greater spectacle.

*

The sunrise I can watch from the kitchen window. Just as it's coming up, a little gold bar comes over the horizon. It's quite magic.

*

Every time we get the spring I get thrilled.... This was a big theme, and one I could confidently do: the infinite variety of nature.

*

I have never seen an ugly natural landscape. Some places are desolate, but they too have an awesome beauty.

*

A lot of people call these wild flowers weeds, but a lot of people who were standing in the middle of the Garden of Eden wouldn't know they were there.

*

Next spring, I think I might concentrate on the cherry tree. Just draw it every day.

We have lost touch with nature, rather foolishly as we are a part of it, not outside it.

For a glorious
sunrise you
need clouds,
don't you?

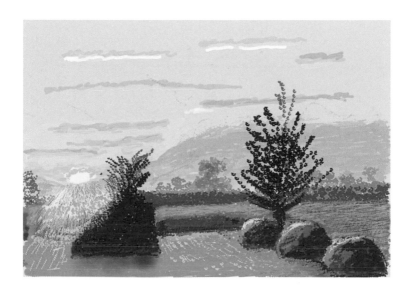

22nd April 2020, No. 2, iPad painting

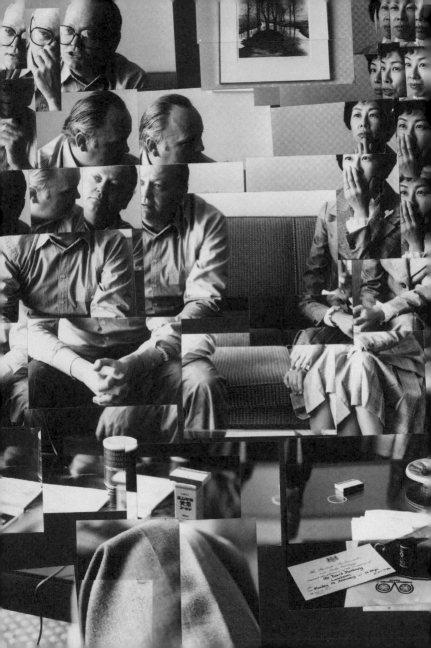

HOCKNEY
ON
PHOTOGRAPHY

Some people think the photograph is reality; they don't realize that it's just another form of depiction.

When a human being is looking at a scene the questions are: What do I see first? What do I see second? What do I see third? A photograph sees it all at once – in one click of the lens from a single point of view.

*

The camera sees geometrically. We don't. We see partly geometrically but also psychologically.

*

Photographs see surfaces, not space, which is more mysterious even than surfaces.

*

Everything on a flat surface is stylized, including the photograph.

*

The spirit of photography is much older than the photograph itself.

*

I think people have been looking at the equivalent of photographs for hundreds of years.

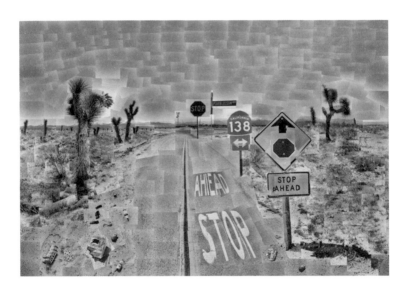

Pearblossom Hwy., 11–18th April 1986 (Second Version),
photographic collage, 181.6 × 271.8 cm (71½ × 107 in.)

Most people feel
that the world
looks like the
photograph.
I believe it almost
does, but not quite.
And that little
bit makes all
the difference.

It's difficult
to photograph
rain. Like dawn,
sunset, and
the moon, it's
another thing
you have to draw.

The history of art is all very comfortable until
the invention of photography. Then it becomes
rather uncomfortable.

*

Van Gogh would not pose for photographs; he didn't
have a high opinion of photography. I assume he
didn't think the world looked like that.

*

Photography is the child of painting.

*

Photography came out of painting and as far
as I can see that's where it is returning.

*

Photographs of gardens are OK, but paintings
of gardens look a lot better.

*

Photographs of sunsets are always clichés because
they show just one moment. They don't have the
movement, so they don't have space. But painted
ones will get that.

The point about the patterns in swimming pools is that they're moving, they don't stay still. If water is moving violently and there's a lot going on, the photograph, which is only capturing a fraction of a second, is in a way quite unrealistic, whereas you can paint it closer to the experience of seeing it.

*

When you pick up the camera and look at things through it, you are very, very deeply conscious of edges. It is the edges that make the composition and it is what you leave there that will enable you to see things in the middle.

*

The photograph is the ultimate Renaissance picture, the mechanical formulation of the theories of perspective of the Renaissance.

*

Reality is a slippery concept. It is not separate from us. But that is what the photograph does: it separates us from the world.

There are an awful lot of people who have stopped
thinking about pictures, who just accept the
photograph as the ultimate visual veracity.
This is it! It isn't 'it' at all. Reality and truth
are always dubious concepts.

*

Have you ever seen *Hello!* or *OK*? This is what's
happened to photography. Everything now is
evened out, polished. If there are six pictures of
six people, they've all got the same expression. If
somebody looks at it in twenty years' time, will they
know who these people are? I don't know even now.
It will tell them something about our shallow age.

*

What was known as 'photography' is now over;
it lasted about a hundred and sixty years.

*

These days, if somebody tells me they are
a photographer, I'm not sure what they do.

*

Everybody's a photographer now, aren't they?
Drawing is far more interesting.

There is no reason why you should believe any more in a photograph than you do in a painting.

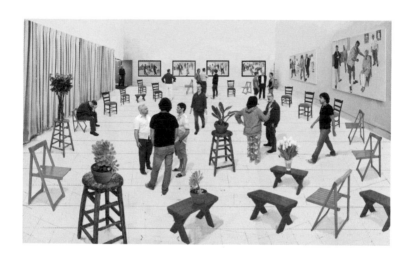

4 Blue Stools, 2014, photographic drawing

HOCKNEY
ON
TECHNOLOGY

I've never been against new things. I try them out and see whether they are good tools for me.... A new piece of technology arrives and then I get new ideas from it.

I'm intrigued by any technology to do with image making: printing, cameras, reproduction itself.

*

I've witnessed printing change a lot. I remember seeing books on Impressionism in art school, and you had to wash your hands before you were allowed to touch them.

*

Technology is allowing us to do all kinds of things today, but I don't think anybody has thought that it could help painting.

*

The computer is a very good tool, but it needs imagination to use it well.

*

Understanding a tool doesn't explain the magic of creation. Nothing can.

*

Technology has always contributed to art. The brush is a piece of technology, isn't it? But tools don't make pictures. People have to make them.

When I discovered
how to use photo-
copying machines
to make prints,
I was very, very
excited. I galloped
away making all
kinds of things.

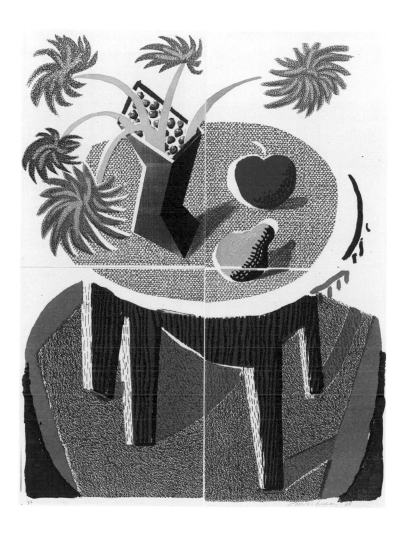

Flowers, Apple & Pear on a Table, July 1986, home made print
on 4 sheets of paper, overall 55.9 × 43.2 cm (22 × 17 in.)

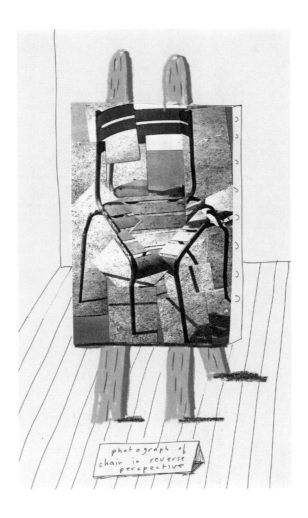

Photograph of Chair in Reverse Perspective, 1988, original template for work of art transmitted by fax: laser copy, collage, crayon, and uni-ball pen on paper, 35.6 × 21.6 cm (14 × 8½ in.)

There's no such thing as a bad printing machine. The fax can be used in a beautiful way.

The fax seemed to me to be an aspect of high technology that brought back intimacy, which, to me, is the only reality.

*

The moment you realize that optics had a deep influence on painting, and were used by artists, you begin to look in a new way.

*

Optics don't make marks – they only produce an image, a look. It requires great skill to render that image in paint.

*

Did Leonardo use optics for the *Mona Lisa*? I don't know, but is it too far-fetched to imagine that he had seen how beautiful the projected image was and wanted to recreate the look himself?

*

Caravaggio made his pictures by a form of drawing with a camera. His paintings are a kind of collage of different projections.

Technology has always altered pictures. Now you have digits. You can do amazing things with them. The digits have freed us.

*

Photoshop is a terrific medium. You don't look at your hand, you look at the screen. You miss some things – you miss texture – but you gain a lot.

*

I find people are interested in my iPhone and iPad drawings because they know they are done by hand.

*

The iPhone makes you bold, and I thought that was very good.

*

The iPad can be what you want it to be. Picasso would have gone mad with it.

*

The iPad is a real new medium. You miss the resist of paper a little, but you can get a marvellous flow. So much variety is possible.

I draw flowers every day on my iPad and send them to my friends so they get fresh blooms every morning.

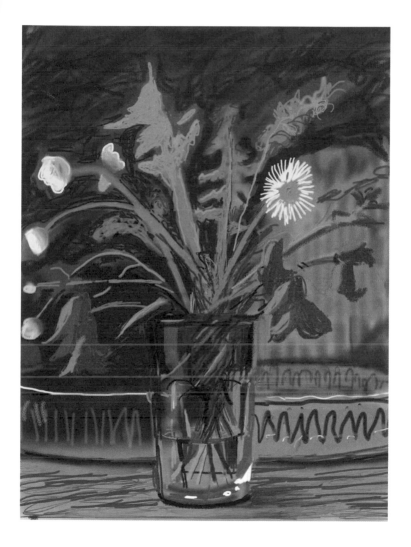

Dandelions, 2011, iPad drawing

On the iPad, I can catch the light very quickly.
I think it's the fastest medium I've ever found,
much faster than watercolour.

*

You can't overwork the iPad, because it's not a
real surface. You can put a bright blue on top of an
intense yellow. But you still have to think in layers.

*

Until I saw my drawings replayed on the iPad, I'd
never actually seen myself draw. Someone watching
me would be concentrating on the exact moment,
but I'd always be thinking a little bit ahead.

*

When I was asked to design a stained-glass window
for Westminster Abbey I began by making a sketch
on my iPad. It might last longer than any of my
other pictures. The Abbey has stood for a thousand
years; perhaps it will still be there at the beginning
of the next millennium.

*

I wasn't too impressed by 3D television. I thought it
would be great for pornography, because you get an
immediate sense for volumes ... not for much else.

You can live in a virtual world if you want to,
and perhaps that's where most people are going
to finish up – in a world of pictures.

*

At one time, there were only a few pictures around;
now there are ever-increasing billions each year.

*

There are many handmade images in the
digital world.

*

The hand, heart, and eye are more complex
than any computer.

*

High tech needs low tech – they are forever joined.

*

I'm finished with the iPad for a bit. I learned a lot
doing it, about marks made on an iPad, but then
I wanted to go back and make marks on paintings.

*

It's always back to the drawing board. Always. Even
on the computer, it's back to the drawing board.

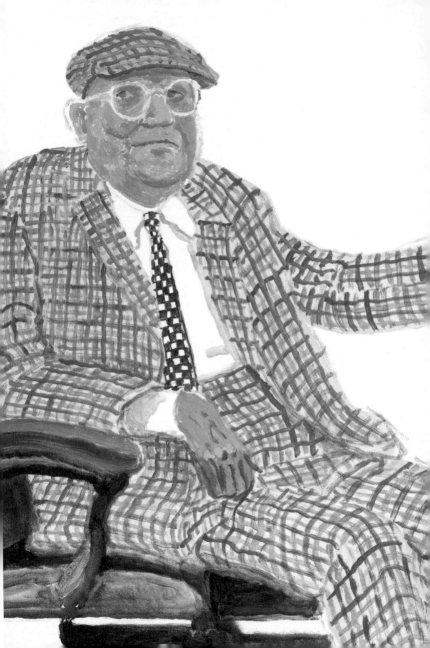

HOCKNEY
ON HOCKNEY
...NOW

Artists can live to a ripe old age because they
don't think about their bodies too much.

*

I'm still smoking, and enjoying it *enormously*.

*

I just love tobacco and I will go on smoking
until I fall over. Like trees, we are all different,
and I'm absolutely certain I am going to die. In fact,
I'm 100 per cent sure I'm going to die of a smoking-
related illness or a non-smoking-related illness.

*

I wake when it starts getting light; I leave
the curtains open.

*

I'm incredibly daylight-conscious. That's why
I always wear hats, to minimize dazzle and glare.

*

I find, as I get older, that life gets more interesting.

*

You notice more with each successive year;
I am doing that now.

I love life.

*

I can enjoy life on a simple level. I can amuse myself.... I don't need anything to pass the time; I need a project.

*

A friend was arranging to see me and she asked, 'Where's your diary?' I said, 'I don't have a diary, because it's always full already.'

*

I might not go out much but I like people around, coming to visit.

*

I like people to come and stay. I'm not anti-social; I'm just unsocial.

*

I'm not one to fall out with people. There are some people I don't see, but it's because they're so boring.

*

I don't see that many artists now. I'm just concerned with my own work.

I've locked myself
away in a nice house
in Normandy where
I can smoke and
do what I want.
And that's where
I'm going to stay.

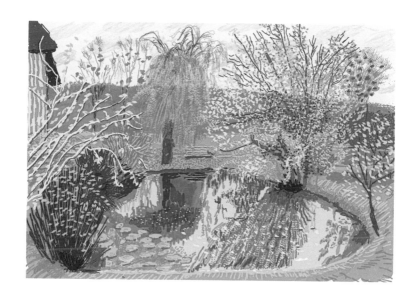

1st November 2020, iPad painting

The best form of living I've seen is Monet's – a modest house at Giverny, very good kitchen, two cooks, gardeners, a marvellous studio. What a life! All he did was look at his lily pond and garden.

*

If you ask me where I live, I'd always say it's wherever I happen to be.

*

I like silence and I like solitude. That's why I'm not that keen on the big city.... In LA, there's always a permanent rumble. In New York, it's worse. I don't want to go there again if I can help it; it's not a place for me at my age. I could never work there – there would be constant visitors.

*

I suffer from the urge to jump off high places like a bird. It is an incredibly physical feeling, in the body. What is it? Is it that you want to fly? Is it because you want the feeling of more freedom?

*

I can ignore a lot of the time what other people might say. I am confident.

I have a tendency, I think, to just dislike the crowd; if the crowd goes one way, I think my natural instinct says: Go the other way, David.

*

I never go in pubs, because at the time I would want to go in them they're just about to close.

*

I'm a terrible teacher.

*

I'm rather against painters making big polemical statements in catalogues.

*

People in England don't complain enough. I am always complaining.

*

I just let politics do what it's doing. I'm not interested enough. I'm interested in other things.

*

Part of my job as an artist is to show that art can alleviate despair.

It is an artist's responsibility to be concerned about the world.

*

It is curiosity that keeps you going.

*

Just because you're cheeky, does not mean you're not serious.

*

I can honestly say that, for the last sixty years, every day I've done what I want to do. Not many people can say that.

*

I get a thrill out of my own pictures. If you didn't, you'd give up, wouldn't you?

*

I would never have expected to be painting with such ambition at this age.

*

I'm aware that I'm quite a popular artist. I assume it's because my painting works on a lot of levels, that's all. I don't give it a great deal of thought.

I don't reflect too much. I live now. It's always now.

*

I live the same way as I have for years; I'm just
a worker. Artists are.

*

[I used to say] I am always working. I know some
people think I spend my time just swimming around
or dancing in nightclubs. That's fine. But I don't,
actually. I work most of the time because it excites
me and gives me very great pleasure.

*

I sit in the studio a lot, just taking in the pictures. I
like being in here. A bed in the studio would suit me.

*

The work is finished when you fall over. That's what
is going to happen. I will just fall over one day.

*

Most artists are going to be forgotten. That's their
fate. It might be mine too, I don't know. I'm not
forgotten yet. It's OK if I am; I'm not sure it's that
important.

I want now to
spend my time
quietly doing
my work. I have
got a lot to do.

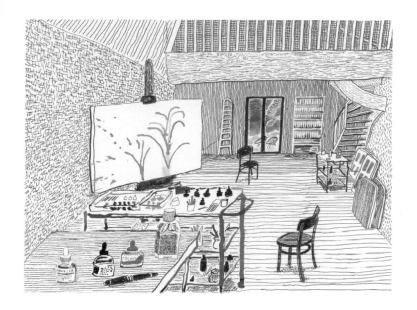

In the Studio, 2019, ink on paper, 57.5 × 76.8 cm (22⅝ × 30¼ in.)

SOURCES

David Hockney, *David Hockney by David Hockney* (Thames & Hudson, 1977)

David Hockney, *That's the Way I See It* (Thames & Hudson, 1993)

David Hockney, *Secret Knowledge* (Thames & Hudson, 2001)

David Hockney, *Hockney's Pictures* (Thames & Hudson, 2004)

Martin Gayford, *A Bigger Message: Conversations with David Hockney* (Thames & Hudson, 2011)

Tim Lewis, 'David Hockney: "When I'm working, I feel like Picasso, I feel I'm 30"', *Guardian*, 16 November 2014

Simon Hattenstone, 'David Hockney: "Just because I'm cheeky, doesn't mean I'm not serious"', *Guardian*, 9 May 2015

Rory Carroll, 'David Hockney does LA again, but differently: "I stay in, I smoke, I feel OK"', *Guardian*, 16 July 2015

'David Hockney Paints Yosemite — on an iPad', *New York Times*, 2 May 2016

David Hockney and Martin Gayford, *A History of Pictures From the Cave to the Computer Screen* (Thames & Hudson, 2016)

Gay Alcorn, 'David Hockney: "I wasn't keen on Hillary when she banned smoking in the White House"', *Guardian*, 11 November 2016

Deborah Solomon, 'David Hockney, Contrarian, Shifts Perspectives', *New York Times*, 5 September 2016

Kirsty Lang, 'David Hockney talks marijuana, cheating death and his new passion', *The Times*, 8 February 2020

Jack Malvern, 'The secret to feeling young? Painting and sex, says David Hockney', *The Times*, 3 August 2020

David Hockney and Martin Gayford, *Spring Cannot be Cancelled: David Hockney in Normandy* (Thames & Hudson, 2021)

Jonathan Jones, 'David Hockney on joy, longing and spring light: "I'm teaching the French how to paint Normandy!"', *Guardian*, 10 May 2021

Françoise Mouly, 'David Hockney Rediscovers Painting', *New Yorker*, 17 February 2022

Waldemar Januszczak, 'David Hockney: "I want to get on with my work"', *Sunday Times*, 13 March 2022

Jonathan Jones, 'David Hockney: "My era was the freest time. I now realise it's over"', *Guardian*, 6 July 2022

Melvyn Bragg, 'David Hockney: "All I need is the hand, the eye, the heart"', *Sunday Times*, 20 August 2023

CAPTIONS AND CREDITS

Page 2: *Self Portrait III, 20th March 2012*, iPad drawing

Page 12: *Self Portrait*, 1954, oil on board, 45.7 × 35.6 cm (18 × 14 in.) (detail)

Page 38: *Santa Monica Boulevard*, 1978–80, acrylic on canvas,
226 × 614.7 cm (89 × 242 in.) (detail)

Page 60: *Kerby (After Hogarth) Useful Knowledge*, 1975,
oil on canvas, 182.9 × 152.4 cm (72 × 60 in.) (detail)

Page 82: *Cyclamen, Mayflower Hotel, New York*, 2002,
watercolour and crayon on paper, 50.8 × 35.6 cm (20 × 14 in.) (detail)

Page 96: *Self Portrait with Charlie*, 2005,
oil on canvas, 182.9 × 91.4 cm (72 × 36 in.) (detail)

Page 122: *The Arrival of Spring in Woldgate, East Yorkshire in 2011
(twenty eleven),* oil on 32 canvases, each 91.4 × 121.9 cm
(36 × 48 in.), overall 365.8 × 975.4 cm (144 × 384 in.) (detail)

Page 136: *Paul Explaining Pictures to Mie Kakigahara, Tokyo,
Feb. 1983*, photographic collage, 88.9 × 114.3 cm (35 × 45 in.) (detail)

Page 148: *Bradford Bounce, Feb. 1987*,
colour xerox, 2 panels, 38.1 × 55.9 cm (15 × 22 in.) (detail)

Page 162: *Self-Portrait, 10th December 2021*, acrylic on canvas,
91.4 × 76.2 cm (36 × 30 in.) (detail)

*

DAVID HOCKNEY is one of the most influential British artists of the modern era. He has produced work in almost every medium – painting, drawing, stage design, photography and printmaking – and has stretched the boundaries of all of them. His groundbreaking *Secret Knowledge: Rediscovering the Lost Techniques of the Old Masters* is published by Thames & Hudson, as are his books in partnership with Martin Gayford: *A Bigger Message*, *A History of Pictures* and *Spring Cannot Be Cancelled*. Born in 1937, he continues to create and exhibit art, and to inspire enormous admiration and affection worldwide.

MARTIN GAYFORD is a writer and art critic. In addition to the titles mentioned above, his books include *Man with a Blue Scarf: On Sitting for a Portrait by Lucian Freud*; *Modernists and Mavericks: Bacon, Freud, Hockney and the London Painters*; *Shaping the World: Sculpture from Prehistory to Now*, with Antony Gormley; *Love Lucian: The Letters of Lucian Freud, 1939–1954*, with David Dawson; and *Venice: City of Pictures*, all published by Thames & Hudson.

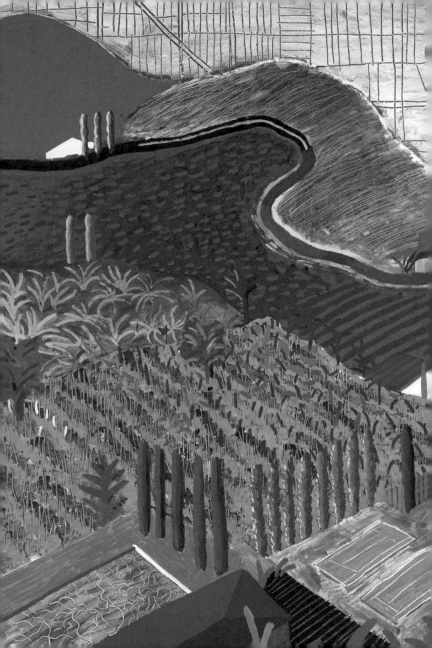